Create
YOUR OWN
Makeup Image

An Artistic Journal by
DESIREÉ DELIA

authorHOUSE®

AuthorHouse™
1663 Liberty Drive
Bloomington, IN 47403
www.authorhouse.com
Phone: 1 (800) 839-8640

Published by AuthorHouse 09/27/2018

ISBN: 978-1-5462-3689-4 (sc)
ISBN: 978-1-5462-3688-7 (e)

Library of Congress Control Number: 2018904231

Cover Illustration by Jennifer Lilya

Print information available on the last page.

Acknowledgement

To the little girl in me who loves to create - Thank you to everyone who has always believed in me – ILY.

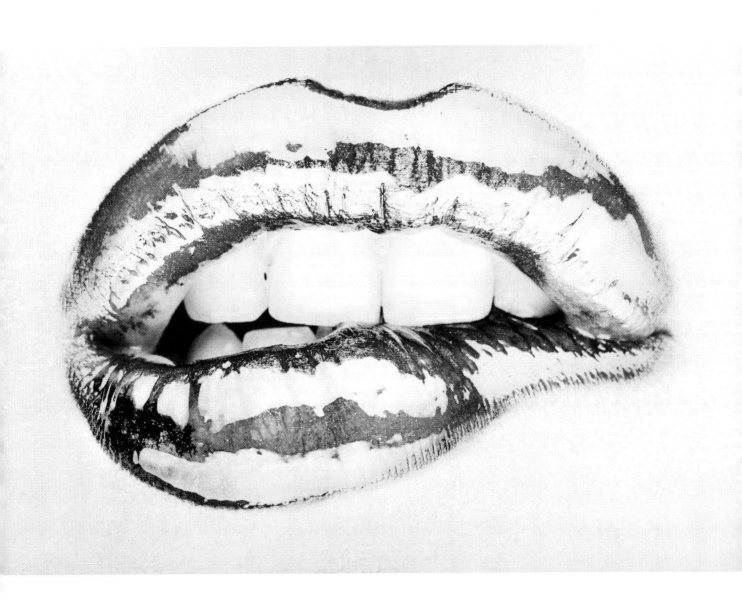

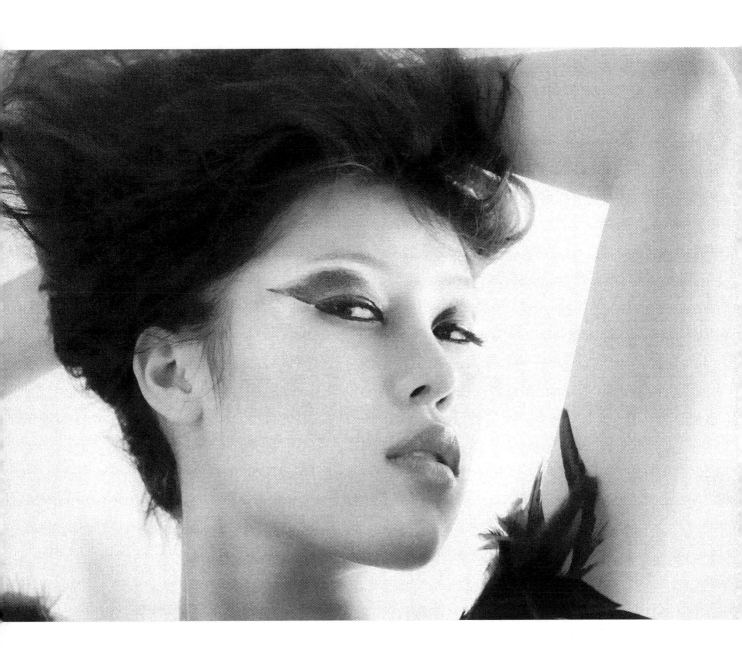

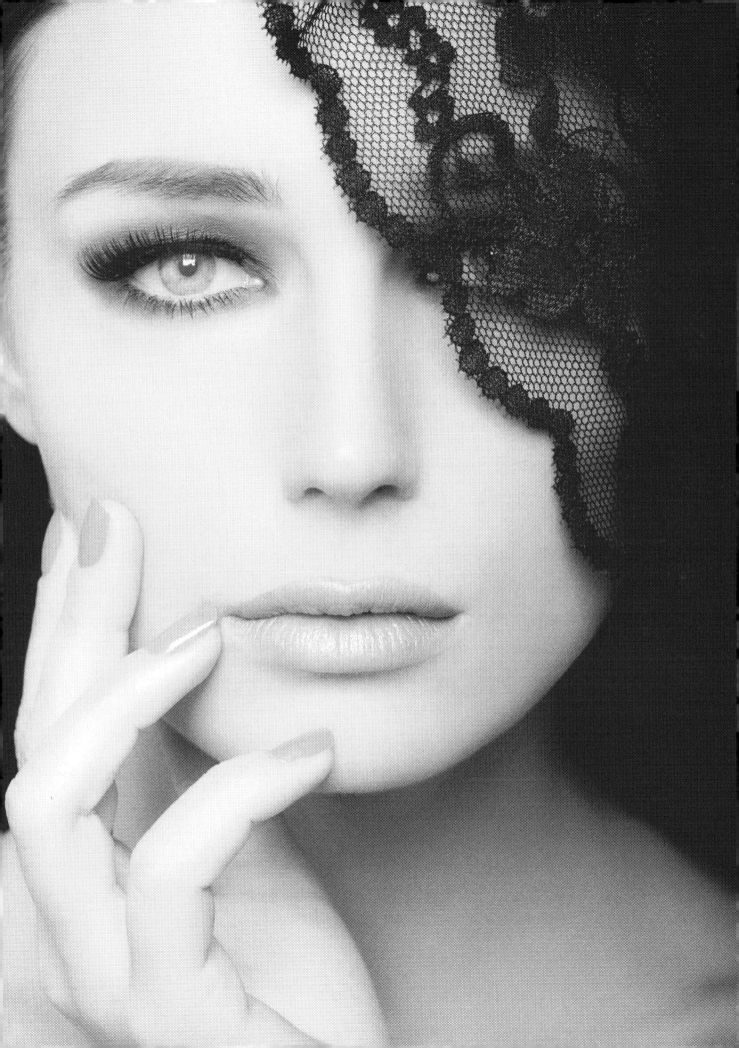

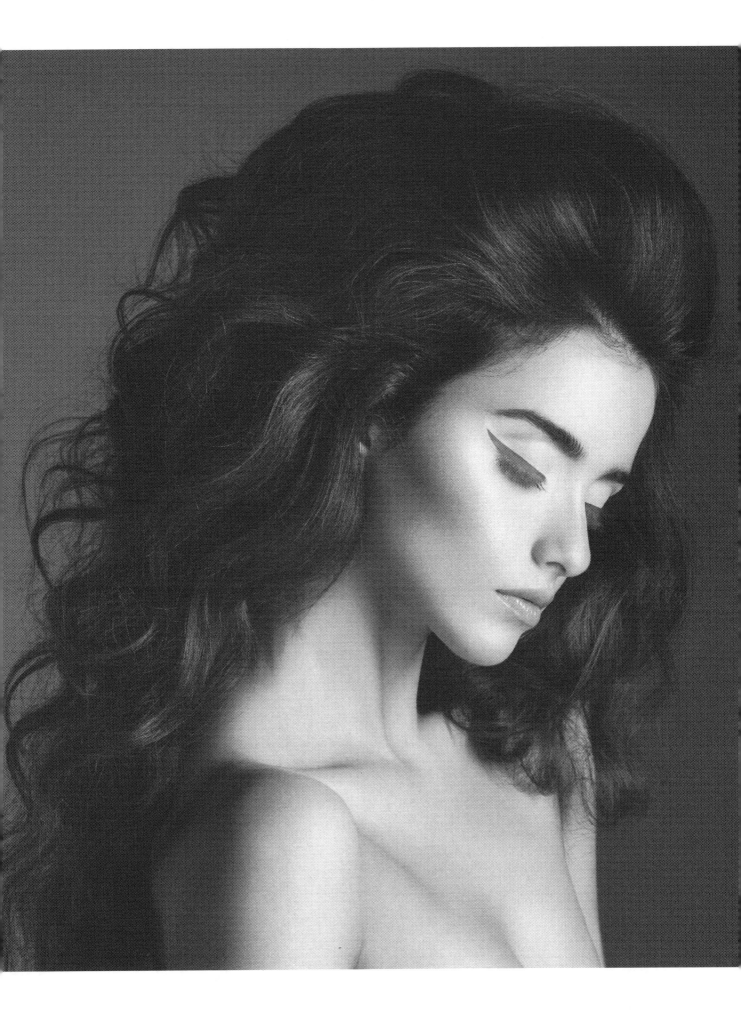

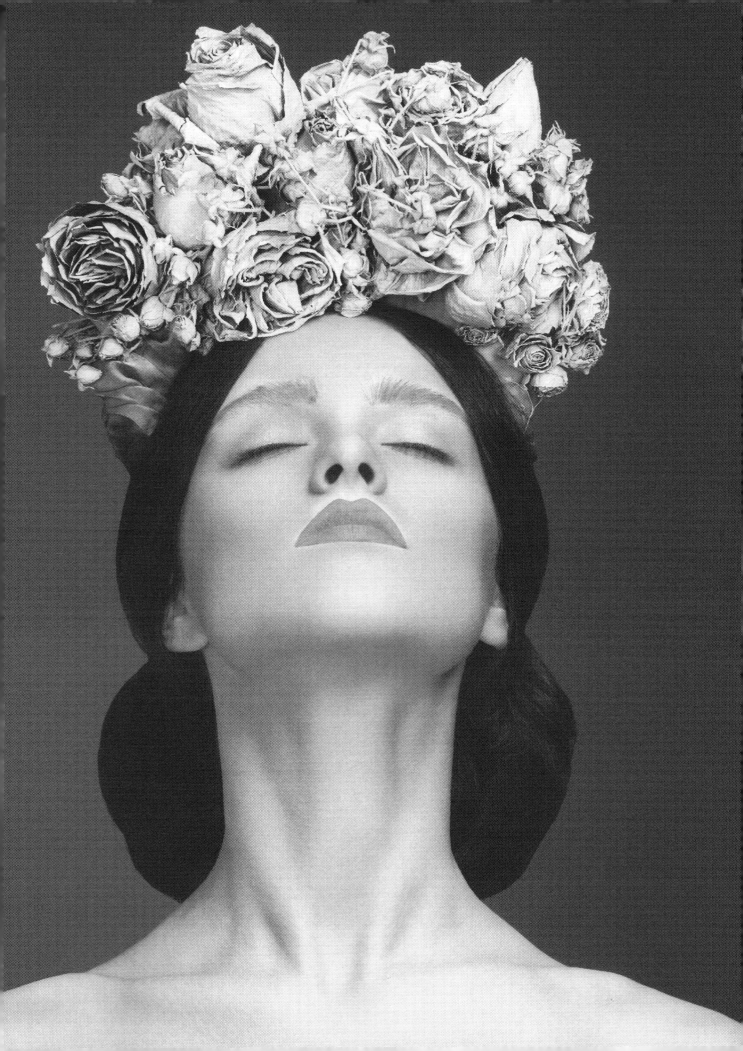

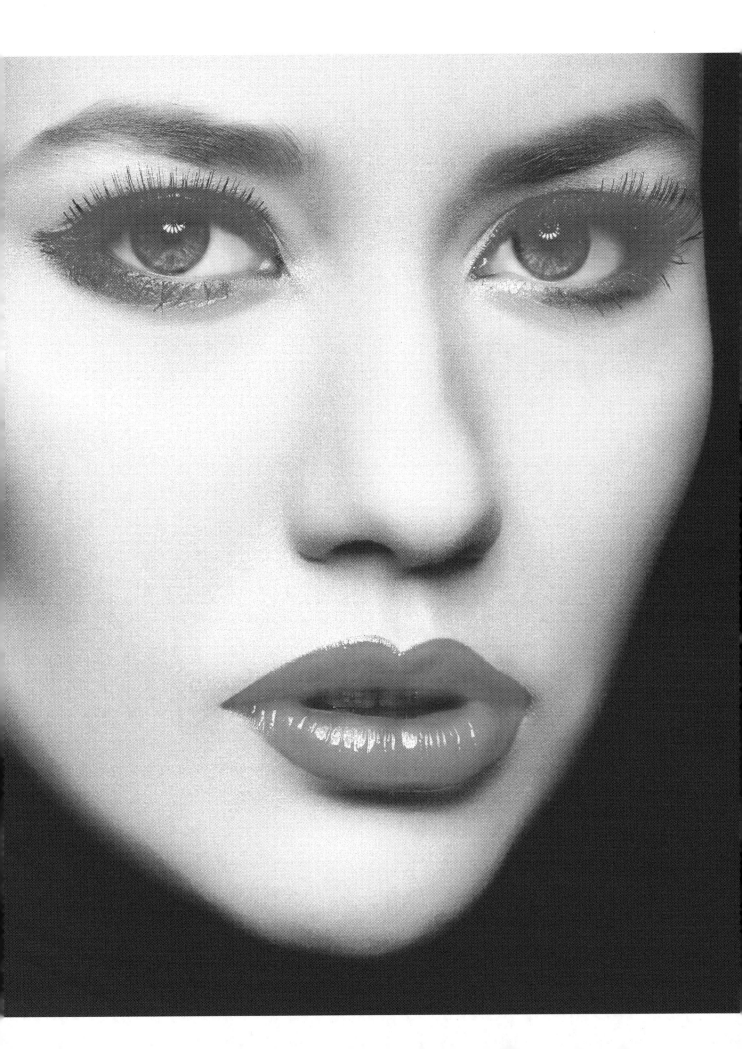

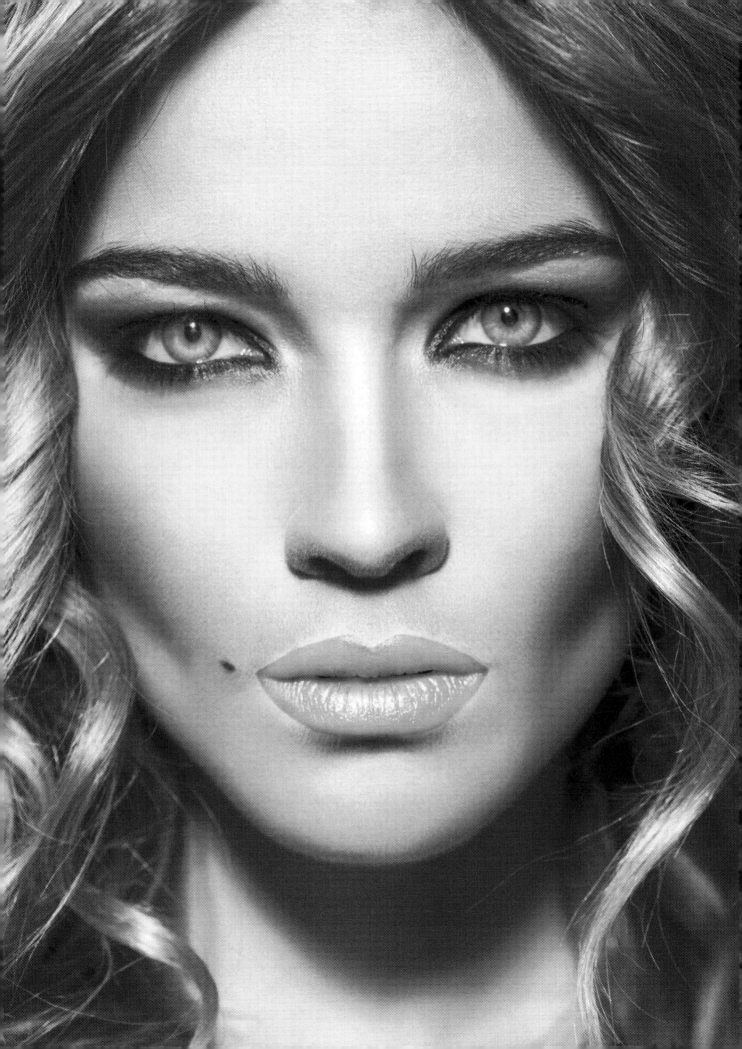

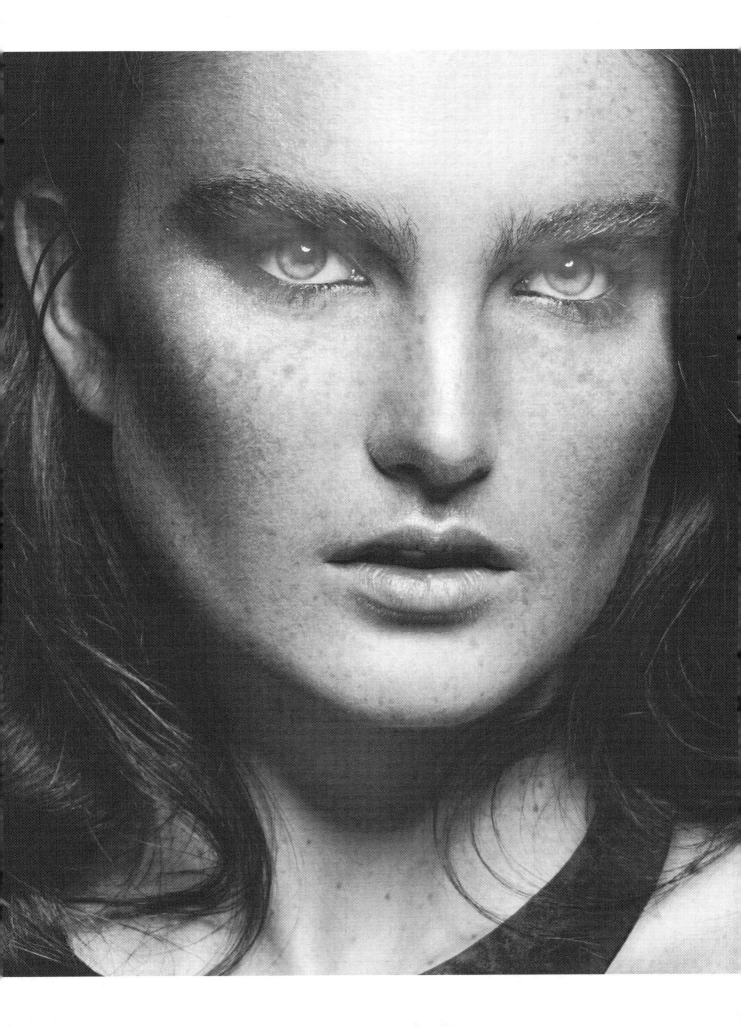

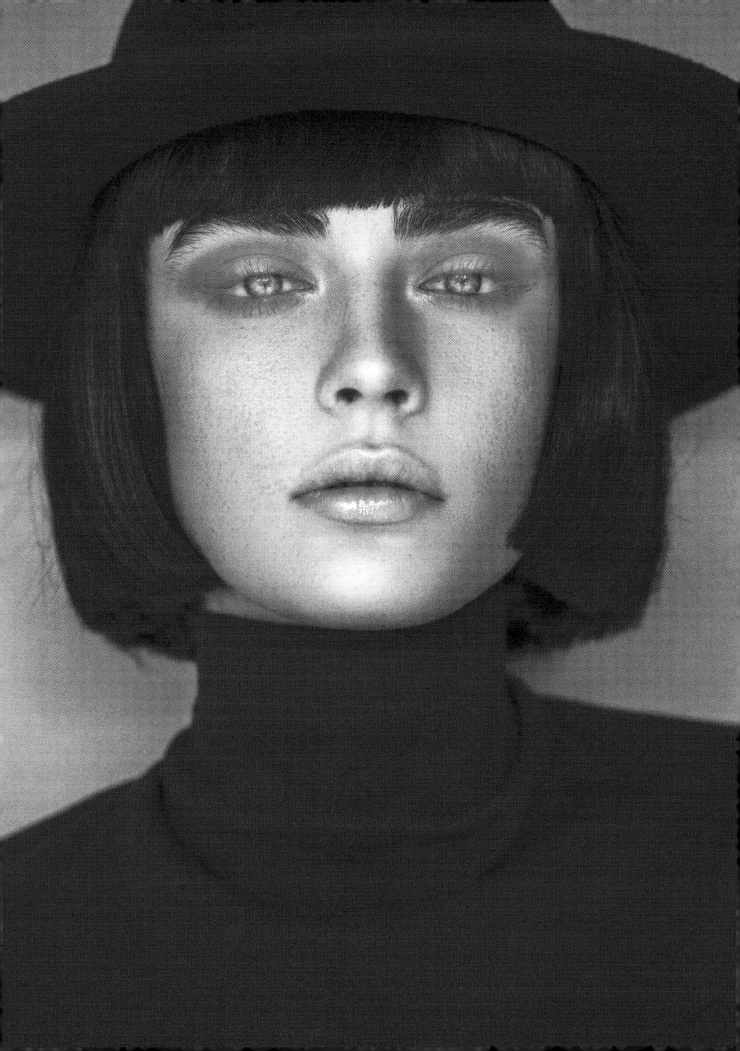

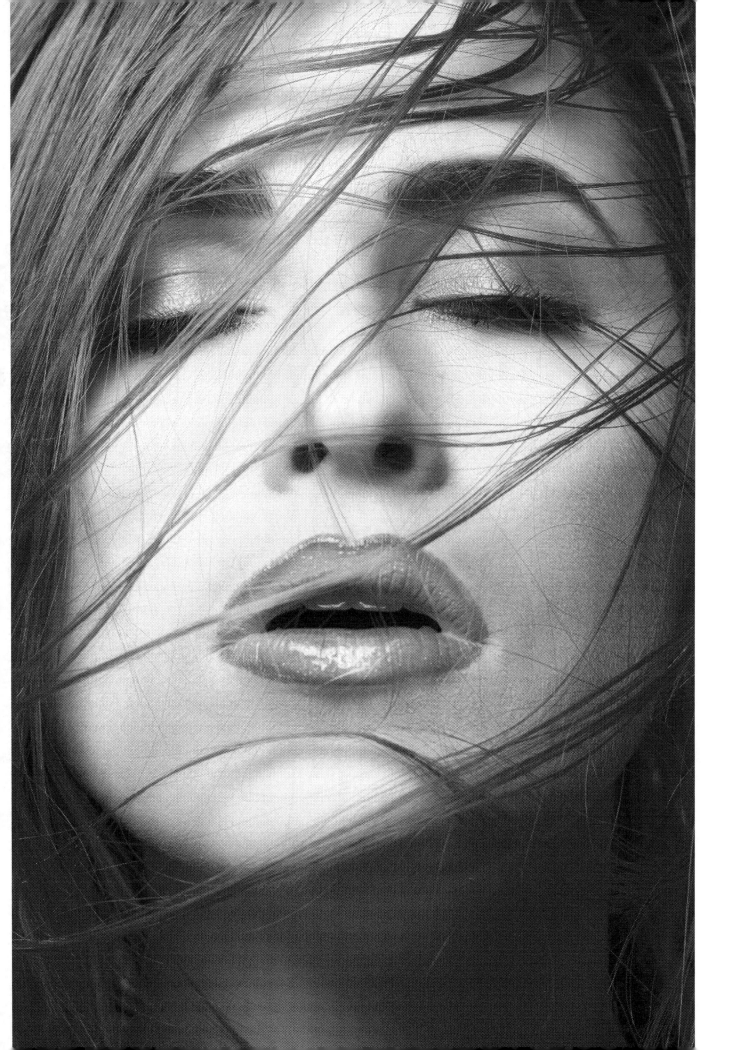

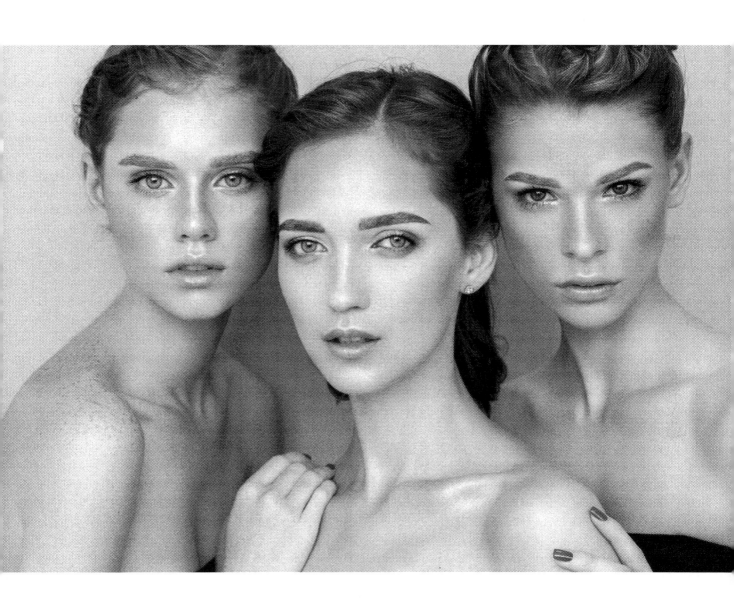

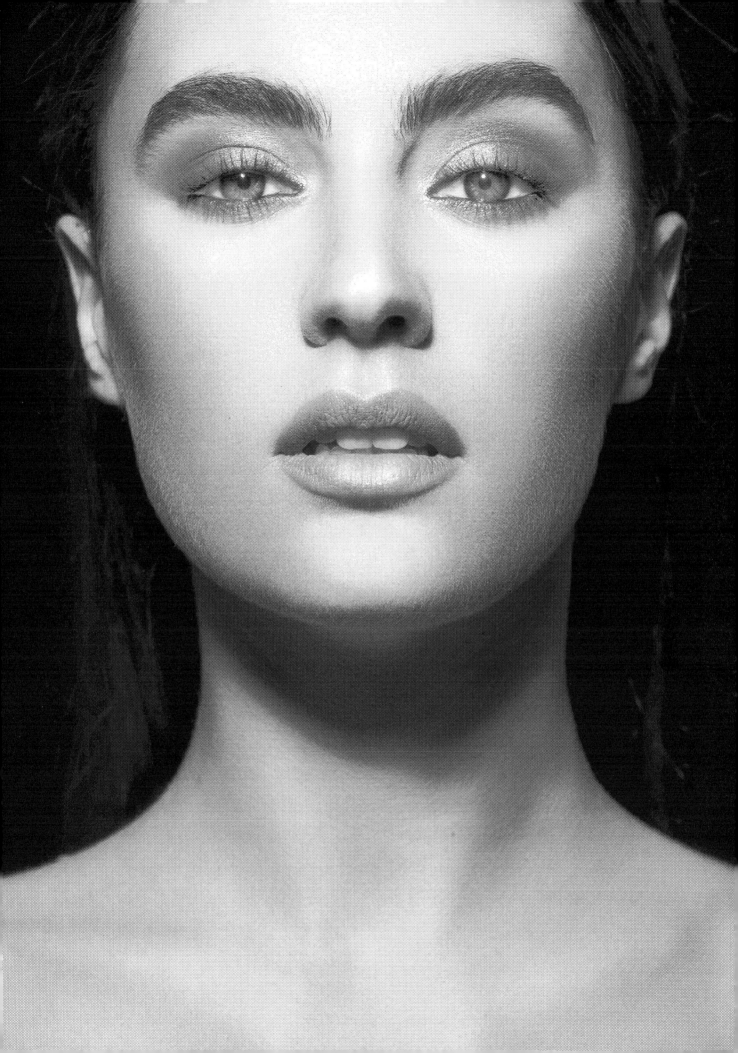

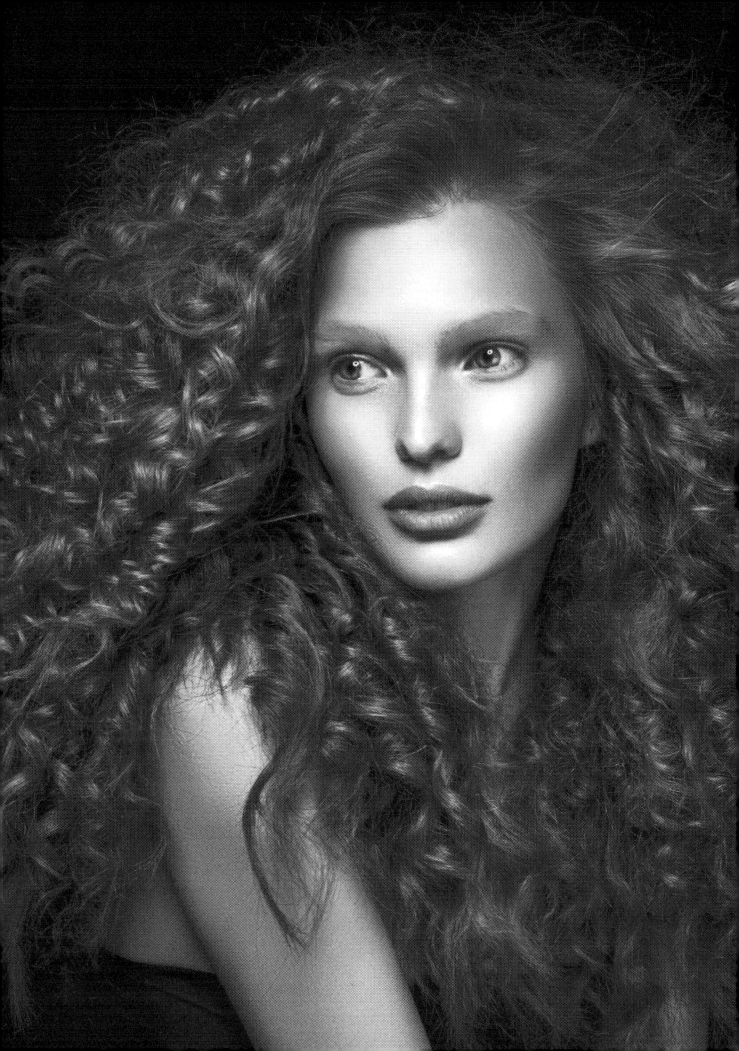

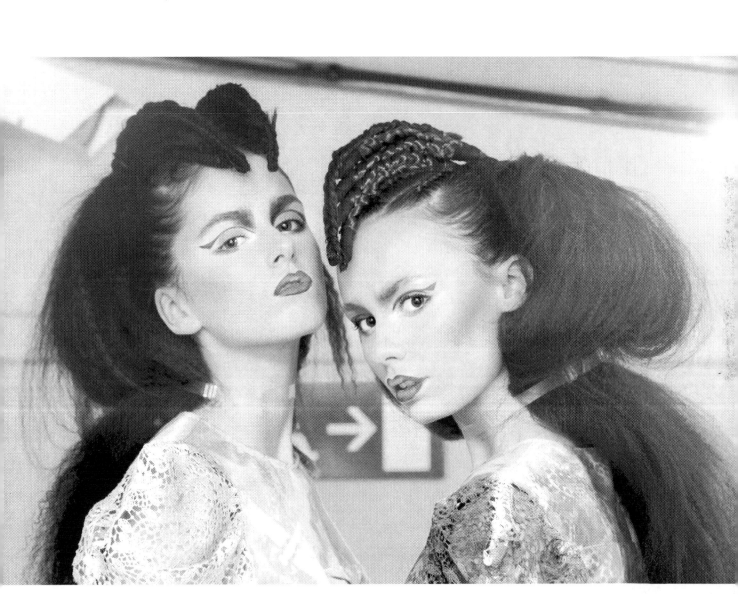

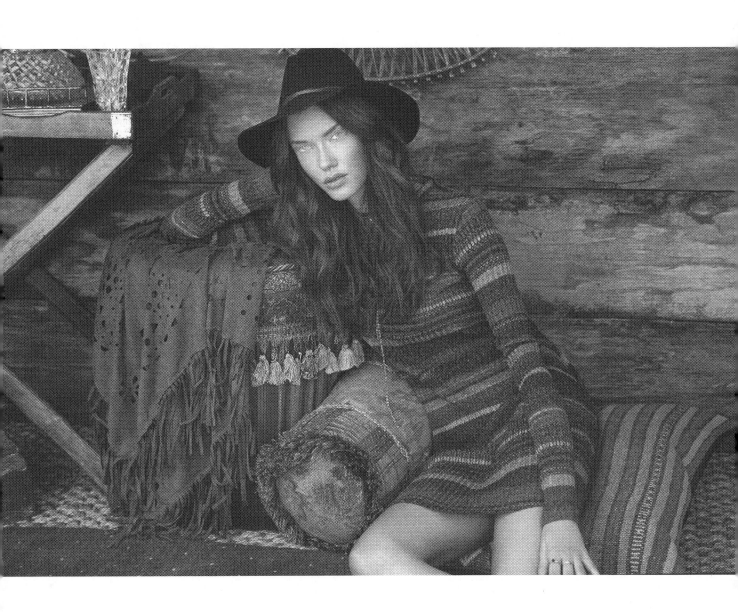

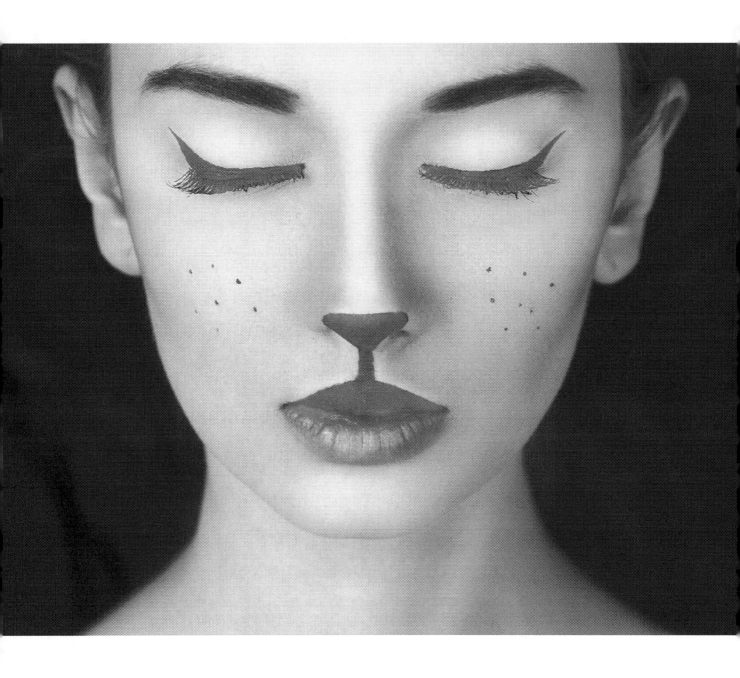

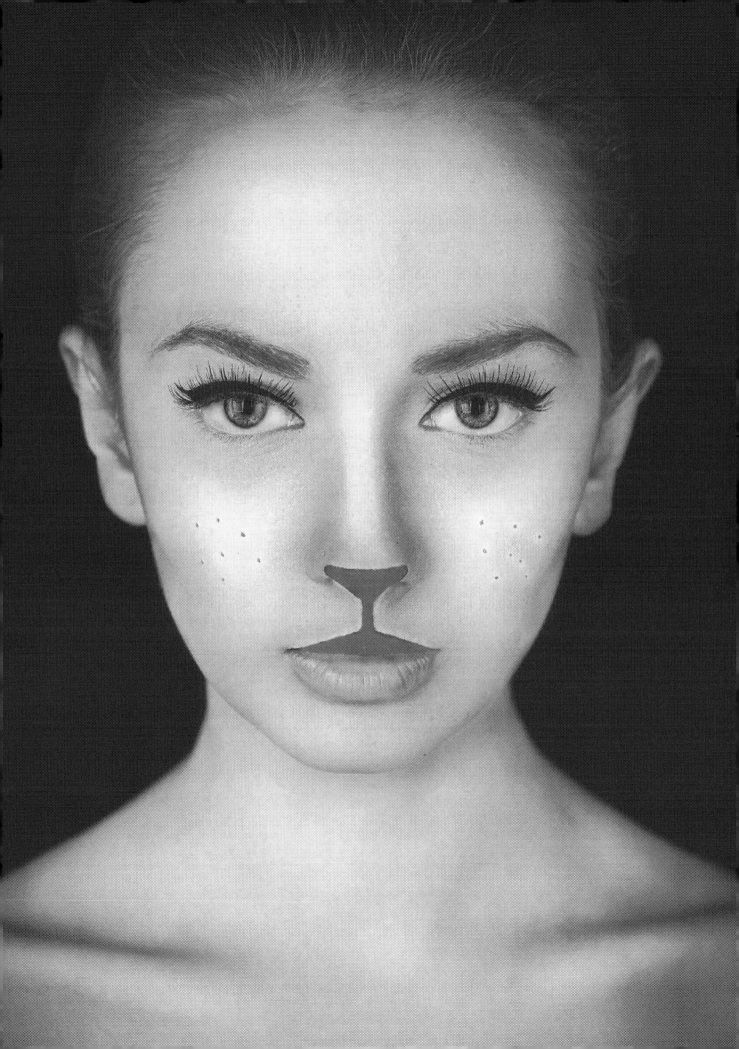

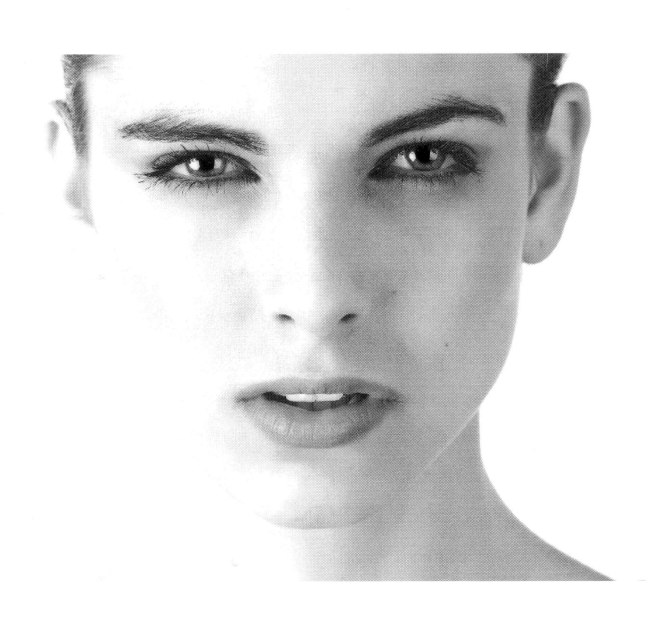

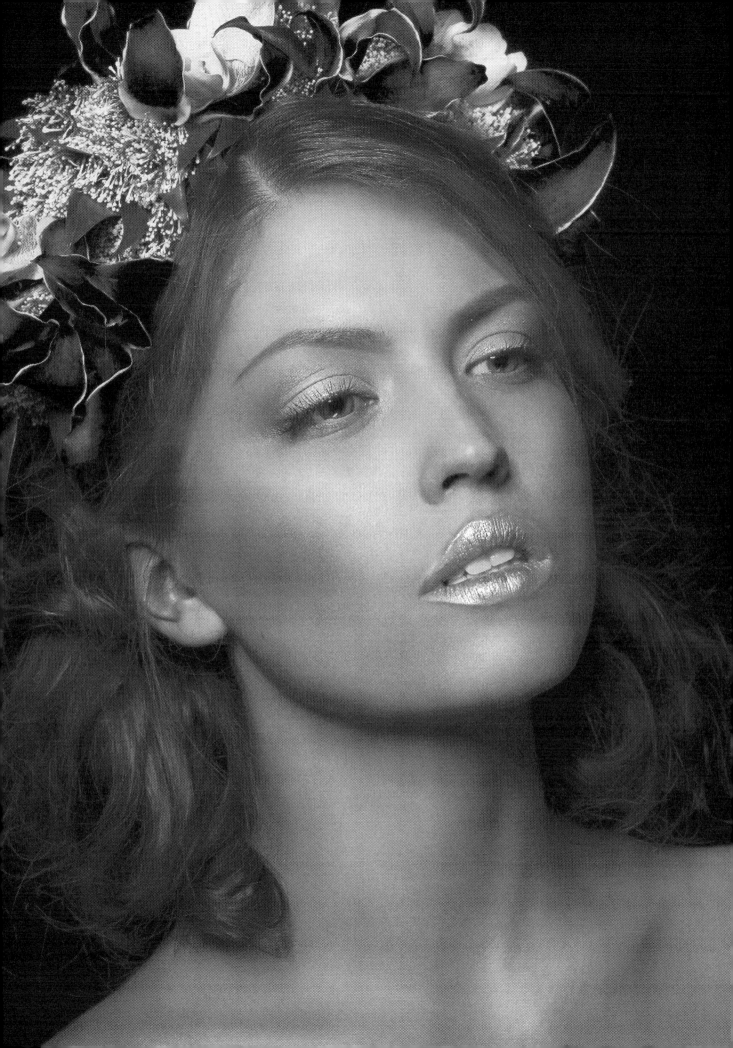

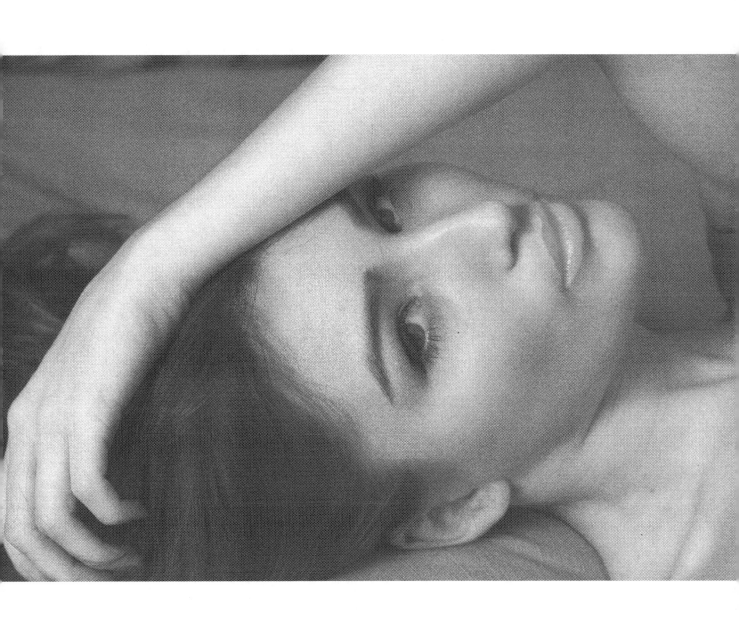

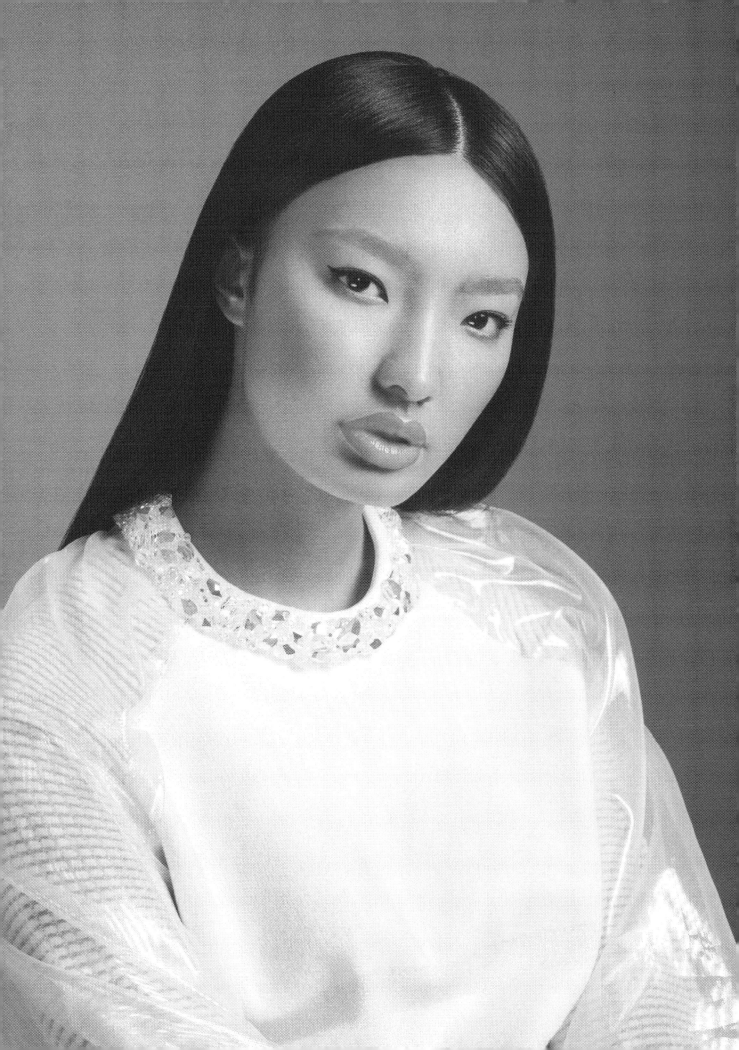

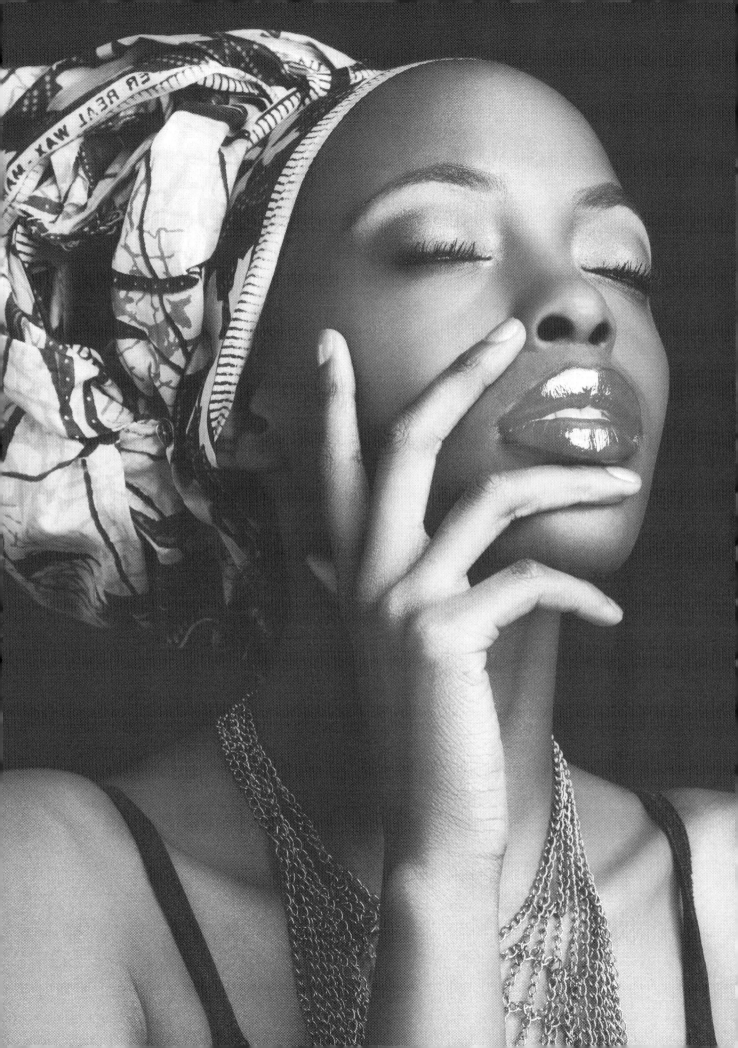

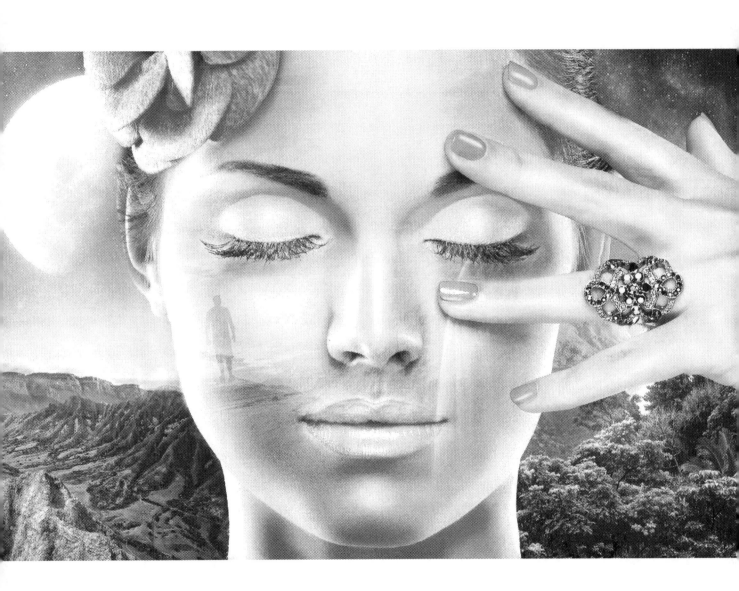

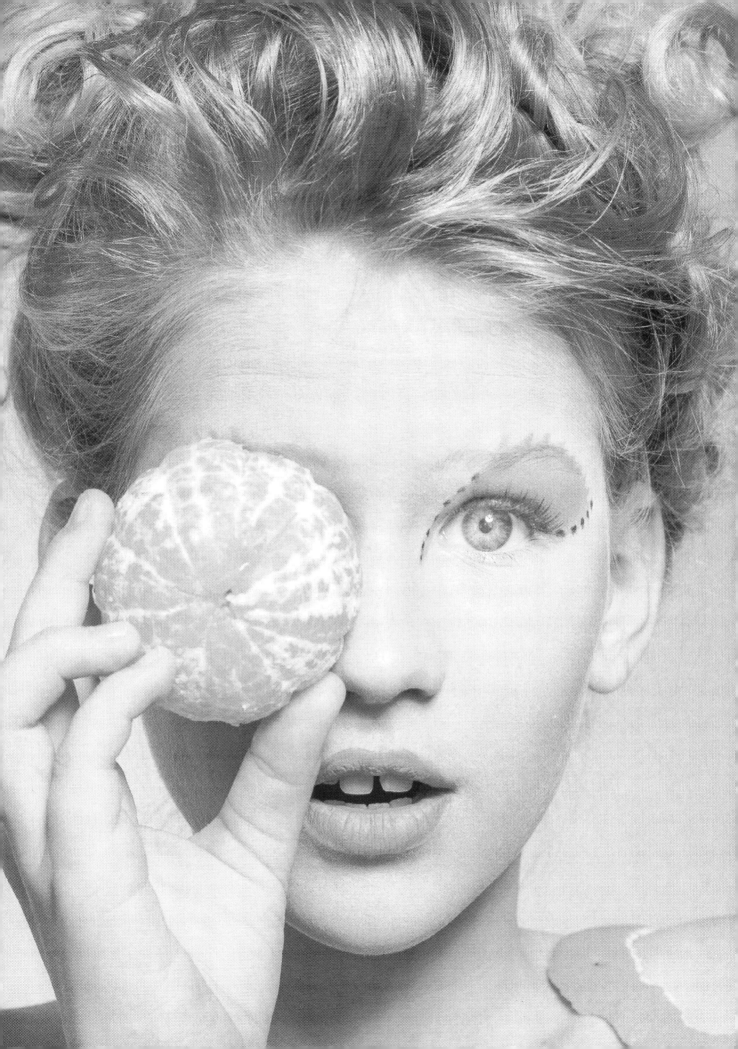

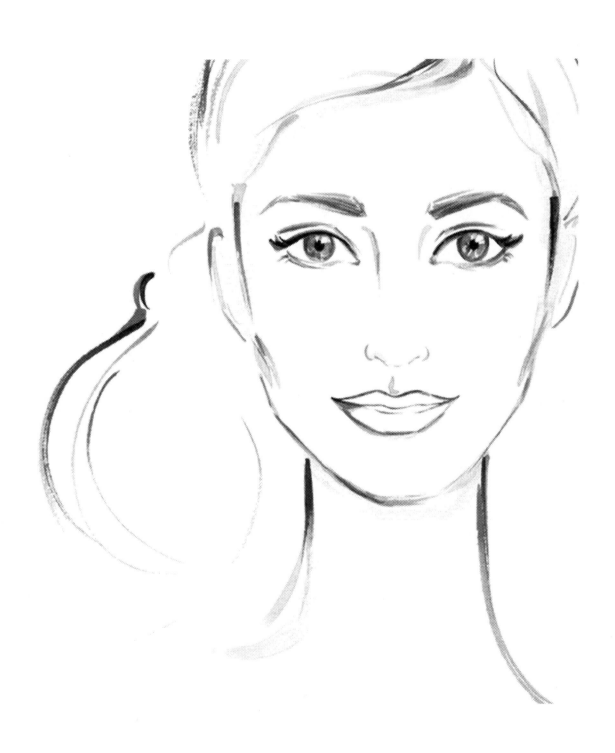

Printed in the United States
By Bookmasters